LOVE

and

Yves Saint Laurent

Concept: Marie-Paule Pellé
Foreword: Patrick Mauriès

Editor, English-language edition: Dena Bunge
Design coordinator, English-language edition: Erin Matherne
 and LeAnna Weller Smith
Translated from the French by Molly Stevens and Nicholas Elliott

Library of Congress Card Number: 00–106527
ISBN 0–8109–3584–8

Printed and bound in France
10 9 8 7 6 5 4 3 2

Harry N. Abrams, Inc.
100 Fifth Avenue
New York, N.Y. 10011
www.abramsbooks.com

Abrams is a subsidiary of LA MARTINIÈRE

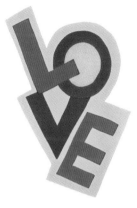

and

Yves Saint Laurent

Harry N. Abrams, Inc., Publishers

FOREWORD

1970–2005: More than three decades that we now associate with different slogans expressing and encapsulating the spirit of the times. When thinking about the 1970s, one cannot help but associate the word *love*—more closed, more compact than the soft pervasive *amour* characterized by the French designer—with *flower power*, the motif par excellence of those years of naive utopia to which we look back from our year 2005 condescendingly and with indulgence after the glorious consumerism of the 1980s and the sinisterly prosaic 1990s.

Perhaps it is because Yves Saint Laurent lives in the grip of the ephemeral, playing with a short-lived object, that he has to—an obvious paradox—forget the slogans of the time and stubbornly and patiently pursue the uncompromising ideals of his desire. This collection of images, discreet traces left behind by the events that occupy existence, are like remains left on the sand by a retreating sea.

One only has to skim through these cards that the couturier impulsively sent to his circle of friends to unravel the specter—in every sense of the word, the color, and the memory—of all those years. Behind the arabesques, the streaks, the guilloche ornamentation, the interlacing re

and blacks and whites, there emerges the echo of Erté, Dunand, Beardsley, and Art Deco, the geometric and lacquered whims of the 1920s and 1930s, reintroduced through the enthusiasm of a spirited time, years when one believed in a liberation. The designs are not so much references or allusions as they are emanations, or subtle distortions.

From here toward other veins, other motifs: doves, ceramic tiles, an ephebe profile, seascapes and Marrakech, flowers (the very picture of selfless splendor), an homage to Matisse, to Braque, or Warhol.... The drawing, the line work, the restricted mediums of the first pieces led to collage, cutout, flat color, and virulent pure tones. But from beginning to end, Yves Saint Laurent was influenced, as he himself has admitted, by a culture not yet dominated by photography, but by line work to express a style: "At that time, there were fantastic illustrated reviews on theater. There were also fashion magazines with drawings by Bérard, Dalí, Cocteau. Today, when you open a newspaper, you don't find great draftsmen like you did then; mostly, you see photographs. This whole magazine ambiance was crucial for me. I remember going to the Grande Librairie to stock up."

Collages, colored pencils, gouaches, markers: these are the traditional tools of creation used in the pages that follow. The images were made with all the joy and feverishness of an amateur indulging in his hobby, of a child drawing with

his tongue sticking out of his mouth. These creations were to be a mark of friendship—those little things that one thinks of only for one's self and a few others, having no pretensions other than to transcribe the impulse of a moment, a particular emotion, an immediate joy.

The expression of this joy is particularly striking in the motif of radiance that proved to be a leitmotif throughout these thirty-five years. The sun's radiance is naturally linked to the landscape of childhood, and to Marrakech, that city in which Saint Laurent settled, and with which he ceaselessly sought connection: "I have such vivid memories of those wonderful days in what was Oran, where I was born. I can see that beautiful city with all races of people together, Algerians, French, Italians, Spanish, leaving their mark of good spirit, cheer, and the craving to live passionately." Even the star, the symbol of lunar mythology, is not introduced here as a nocturnal motif, but rather as something to punctuate enthusiasm, like a spark, like an image of a positive force.

To celebrate love is not to close oneself off complacently from the suffering in the world, nor is it to ignore the violence of reality; indeed, it is the opposite. Only person for whom "to live is a daily battle against anguish," who possesses extreme delicacy, could give all his worth to what for others might be only a formulaic ritual for a spe

cial occasion. One imagines Saint Laurent to be sensitive to all the ambiguities, the heartbreaks, the feelings of plentitude and unencumbered horror that such a note conceals. To love, as someone recently said, is to want to give what one does not have to someone who does not want it. Following, therefore, are some thirty-odd cards, punctuating time, but which celebrate all unexpected findings, the absolute correspondence of an instant, the blunt potential of an encounter, the power of the unforeseen, the power that lights up your life.

<div align="right">Patrick Mauriès</div>

YVES SAINT LAURENT was born on August 1, 1936, in Oran, Algeria. At the age of seventeen, he went to Paris to study fashion. He was hired by Christian Dior whose principal assistant he became before succeeding him when he died in 1957.

Three years later, along with Pierre Bergé, he decided to start his own couture house.

On January 29, 1962, he presented his first collection under the name Yves Saint Laurent.

Along with his haute couture collections, Yves Saint Laurent has also designed costumes for films, theater, opera, and variety shows.

There have been a number of retrospective exhibitions of his work around the world: the Metropolitan Museum of Art in New York (1983), the Palace of Fine Arts in Beijing (1985), the Musée des Arts de la Mode in Paris (1986), the State Hermitage Museum in St. Petersburg (1987), the Art Gallery of New South Wales in Sydney (1987), and the Sezon Museum of Art in Tokyo (1990).

On March 2, 1985, François Mitterrand, the President of the French Republic, personally presented him with the chevalier medal of the Legion of Honor at the Palais de l'Élysée.

On January 1, 1995, Yves Saint Laurent was raised to the rank of officer of the Legion of Honor.

On July 12, 1998, for the final match of the World Cup Soccer tournament at the Stade de France, Yves Saint Laurent put on a 300-model fashion show.

On June 2, 1999, in New York, Yves Saint Laurent was given a Lifetime Achievement Award from the Council of Fashion Designers of America.

On January 22, 2002, a retrospective runway show covering Yves Saint Laurent's forty-year career in fashion was held at the Pompidou Center. More than 300 designs were presented, along with the 2002 Spring-Summer collection, Saint Laurent's last.

On October 31, 2002, the Yves Saint Laurent haute couture house closed.

Since 2002, Yves Saint Laurent has devoted himself to furthering the Pierre Bergé–Yves Saint Laurent Foundation's goals of preserving its collection of 5,000 garments and 15,000 objects and of organizing thematic exhibitions.

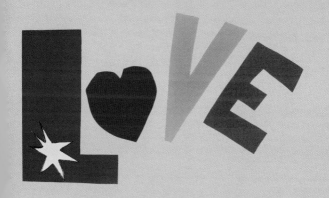

and
Yves Saint Laurent

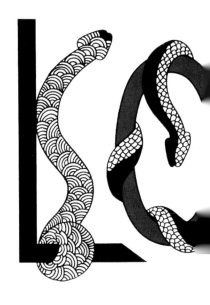

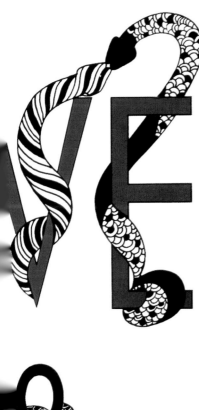

Yves Saint Laurent

Love is like a fever;
it is born and dies away
whether we will it to or not.

De l'Amour, STENDHAL

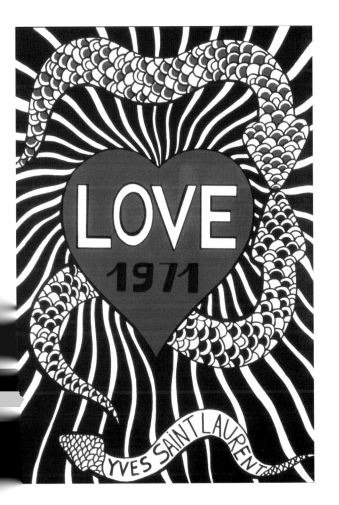

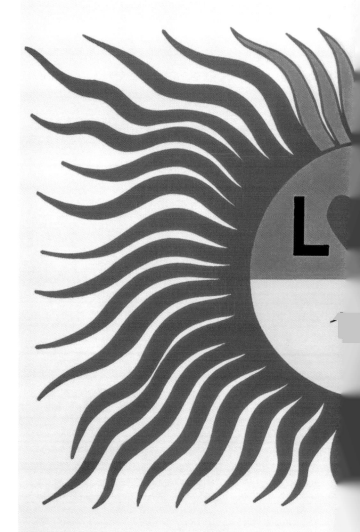

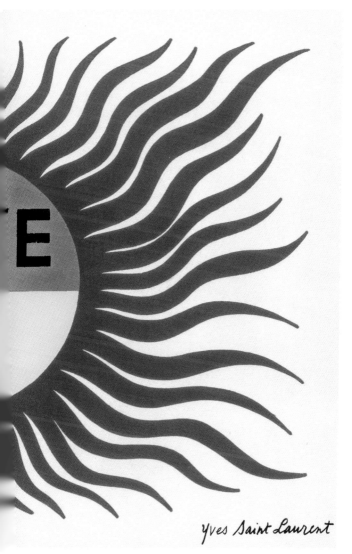

Yves Saint Laurent

. . . Love, this is the great Faith!

Soleil et Chair, Arthur Rimbaud

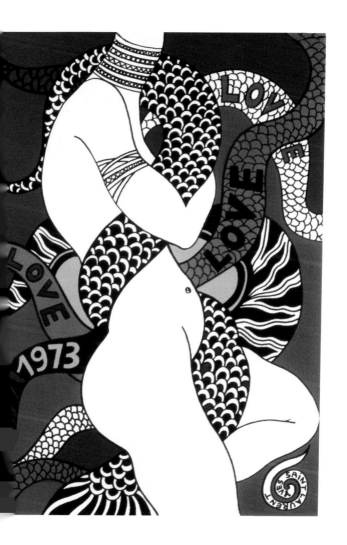

I desire love like one desires sleep.

Le Jour et la Nuit, GEORGES BRAQUE

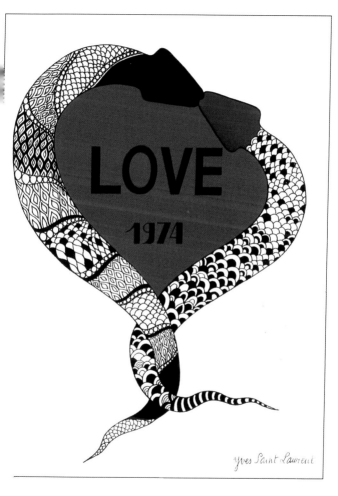

LOVE
1974

yves Saint Laurent

To say that you can love one person for your entire life is like claiming that a candle will continue to burn for as long as you live.

The Kreutzer Sonata, Leo Tolstoy

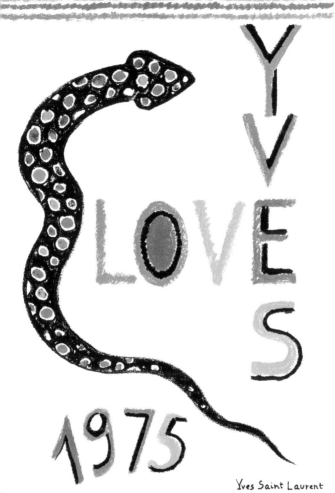

YVES

LOVES

1975

Yves Saint Laurent

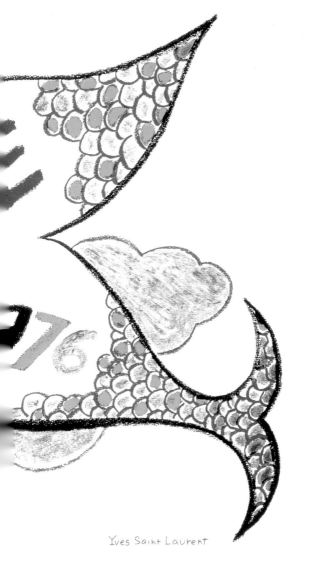

Yves Saint Laurent

It's easier to die than to love.
This is why I go through the trouble
of living my love . . .

Elsa, LOUIS ARAGON

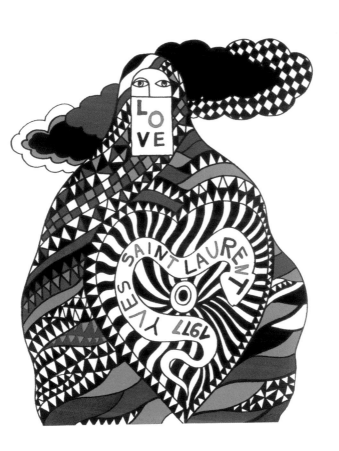

Love is a punishment.
We are punished for not
being able to stay alone.

Fire, MARGUERITE YOURCENAR

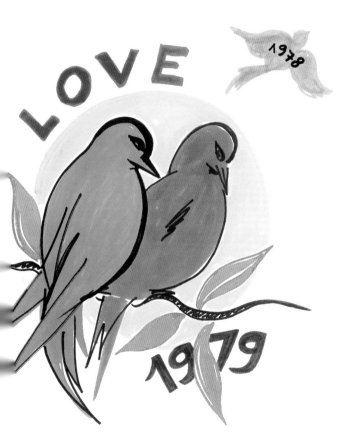

LOVE

1978

1979

Yves Saint Laurent

The measure of love is
to love without measure.

On Love, Saint Augustine

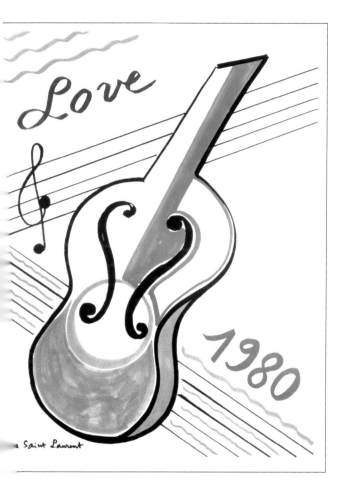

We only love what we do not have.

La Prisonnière, MARCEL PROUST

True love is like an apparition
of spirits: everyone talks about it,
but few have seen it.

Maximes, François De La Rochefoucauld

Yves Saint Laurent

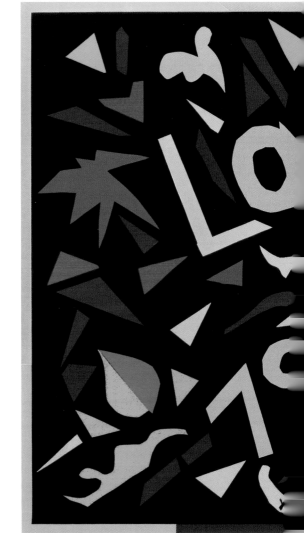

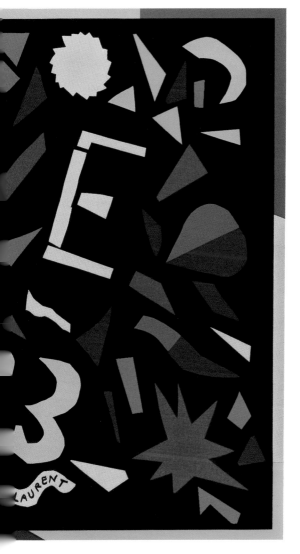

Any thought that is not filled
with love seems unholy.

Journal, 1939–1949, ANDRÉ GIDE

LOVE

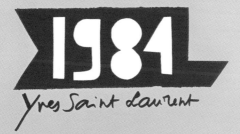

1984

Yves Saint Laurent

Love chooses love
without changing expression.

L'Amour la Poésie, Paul Éluard

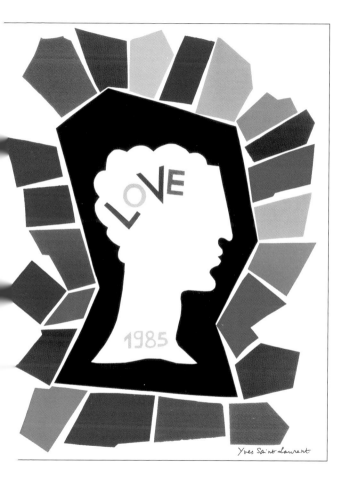

Yves Saint Laurent

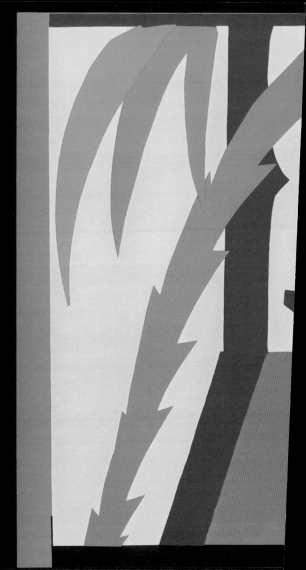

LOVE

6

Yves Saint-Laurent

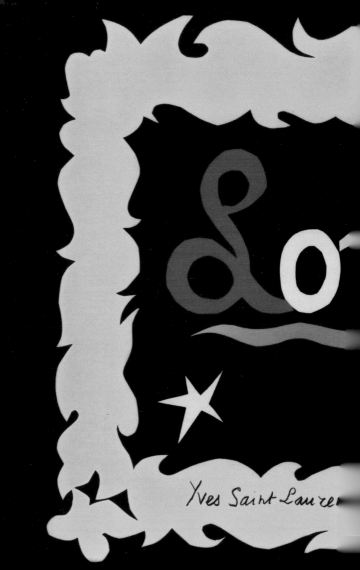
Yves Saint Laurent

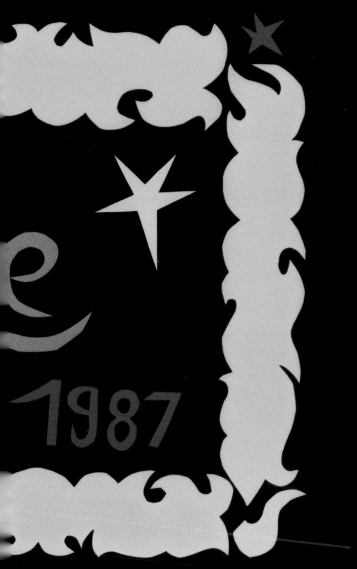

Love takes off the masks
that we fear we cannot live
without, and we know
we cannot live within.

The Fire Next Time, JAMES BALDWIN

YVES SAINT LAURENT

1988

The most beautiful love
means nothing when it is plain;
it needs engraving and silversmithing.

La Fausse Maîtresse, GUSTAVE FLAUBERT

LOVE

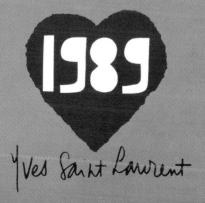

Yves Saint Laurent

No love can take the place of love.

Les Petits Chevaux de Tarquinia,
Marguerite Duras

Love is much more than love.

Claire, Jacques Chardonne

Lui C'est Moujik

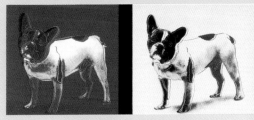

mon chien

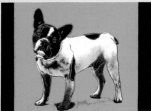

peint par Andy Warhol

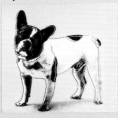

Moi je suis Yves Saint Laurent

Love 1991

That absurd and magnificent thing,
between great evil and supreme good,
that we casually call love.

Suite neuchâteloise, DENIS DE ROUGEMONT

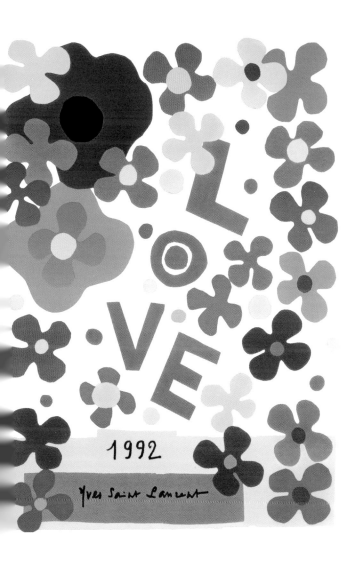

1992

Yves Saint Laurent

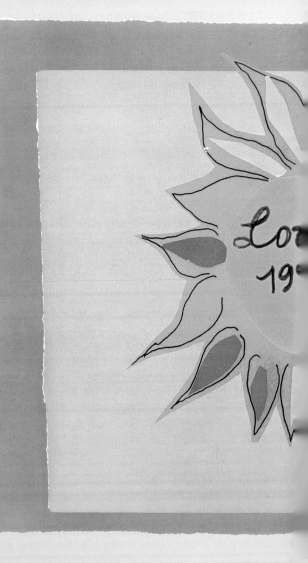

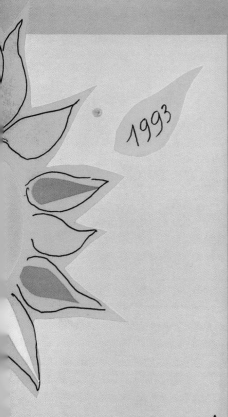

1993

yves Saint Laurent

Love is the only passion
that does not suffer a past or future.

Les Chouans, Honoré de Balzac

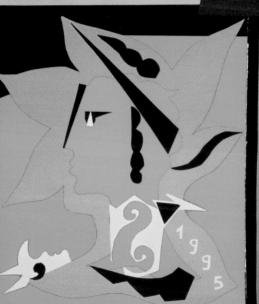

LOVE

1995

Yves Saint Laurent

To be in love is to surpass one's self.

The Portrait of Dorian Gray, OSCAR WILDE

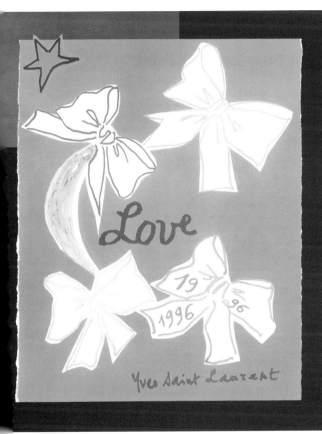

Love gives you spirit

It is supported by the spirit.

One needs to be adroit to love.

Discours sur les Passions de l'Amour,
BLAISE PASCAL

LOVE

1997

Yves Saint Laurent

A great love is perhaps incomplete
without its decline, agony,
without its conclusion.

Les Femmes et l'Amour, SACHA GUITRY

LOVE

1998 Yves Saint Laurent

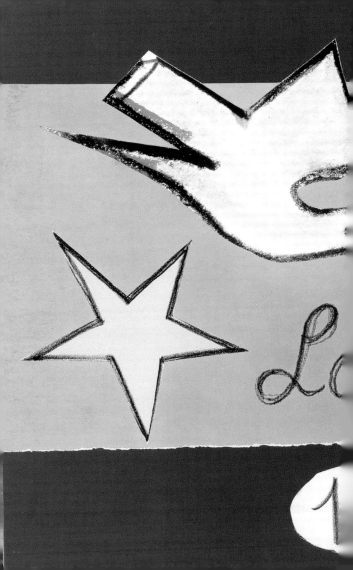

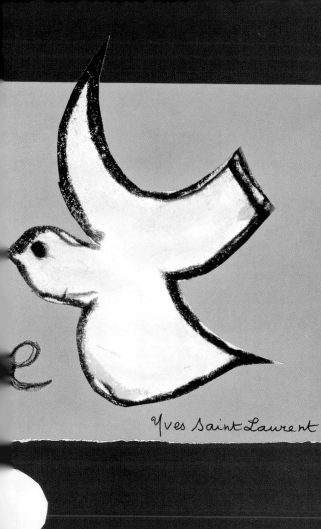

Yves Saint Laurent

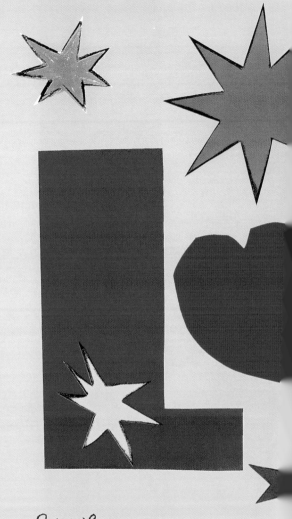

yves Saint Laurent

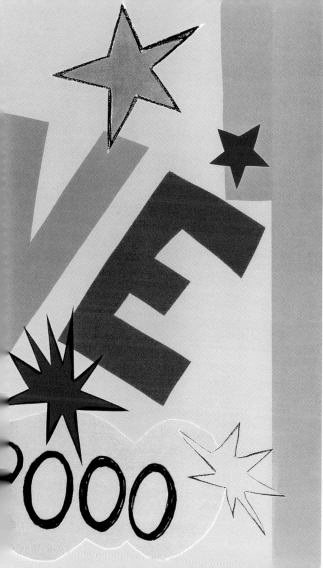

Loving also is action!

Seamarks, Saint-John Perse

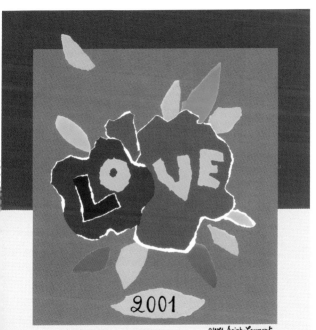

Love, love, the rest is nothing.

The Loves of Psyche and Cupid,

Jean de La Fontaine

LOVE

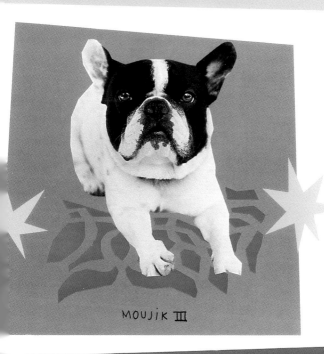

MOUJiK III

2002

Yves Saint Laurent

He who hath lov'd,
must go on loving to the last.

August Night, Alfred de Musset

LOVE

2003

Yves Saint Laurent

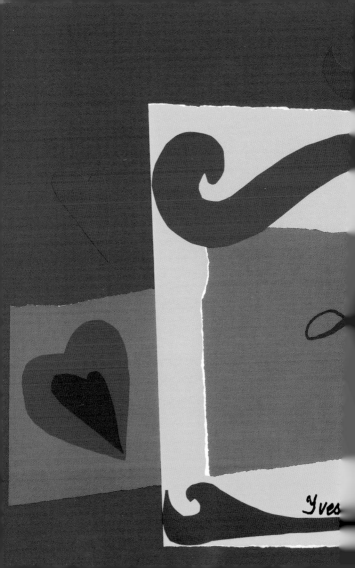

Yves

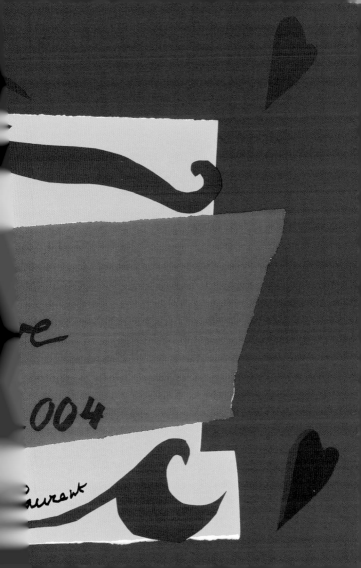

It is true we love life; not because
we do want to live, but because we
do want to love.

Thus Spake Zarathustra, FRIEDRICH NIETZSCHE

ves Saint Laurent

2005